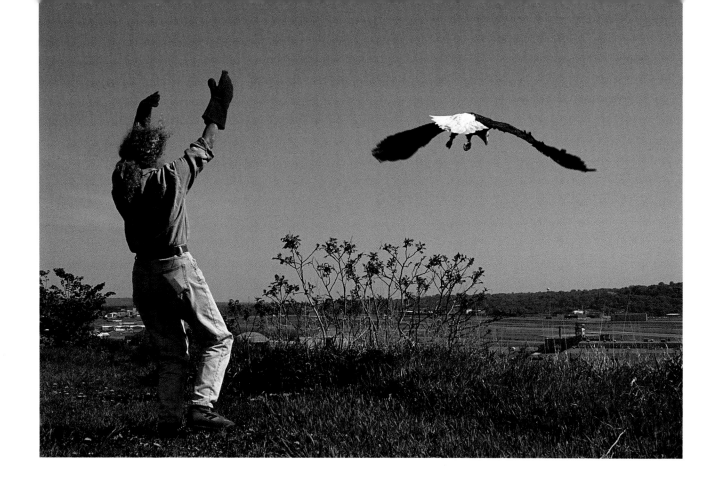

Raptor Rescue!

An Eagle Flies Free

by Sylvia A. Johnson · photographs by Ron Winch

DUTTON CHILDREN'S BOOKS · NEW YORK

ACKNOWLEDGMENTS

For their generous assistance in the making of this book, the author and the photographer would like
to thank the staff and volunteers of the Raptor Center at the University of Minnesota.
Special thanks are given to Dr. Patrick Redig, Director; Ron Osterbauer, Associate Director;
Lori Arent, Patient Care Coordinator; and MaryBeth Garrigan, Information Specialist,
without whose help this book would never have gotten off the ground.

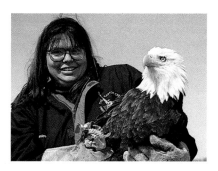

Library of Congress Cataloging-in-Publication Data
Johnson, Sylvia A.
Raptor rescue!: an eagle flies free/by Sylvia A. Johnson;
photographs by Ron Winch.—1st ed. p. cm. ISBN 0-525-45301-6
1. University of Minnesota. Gabbert Raptor Center. 2. Birds of
prey—Wounds and injuries—Treatment—Minnesota–-St. Paul—
Juvenile literature. 3. Bald eagle—Wounds and injuries—
Treatment—Minnesota—St. Paul—Juvenile literature. [1. Bald
eagle—Wounds and injuries—Treatment. 2. Birds of prey—Wounds
and injuries—Treatment.] I. Winch, Ron, ill. II. Title.
SF994.5.U54J64 1995
639.9′78916—dc20 94-41483
CIP AC

Published in the United States 1995 by Dutton Children's Books,
a division of Penguin Books USA Inc.
375 Hudson Street, New York, New York 10014
Designed by Semadar Megged
Printed in Hong Kong
First Edition
10 9 8 7 6 5 4 3 2 1

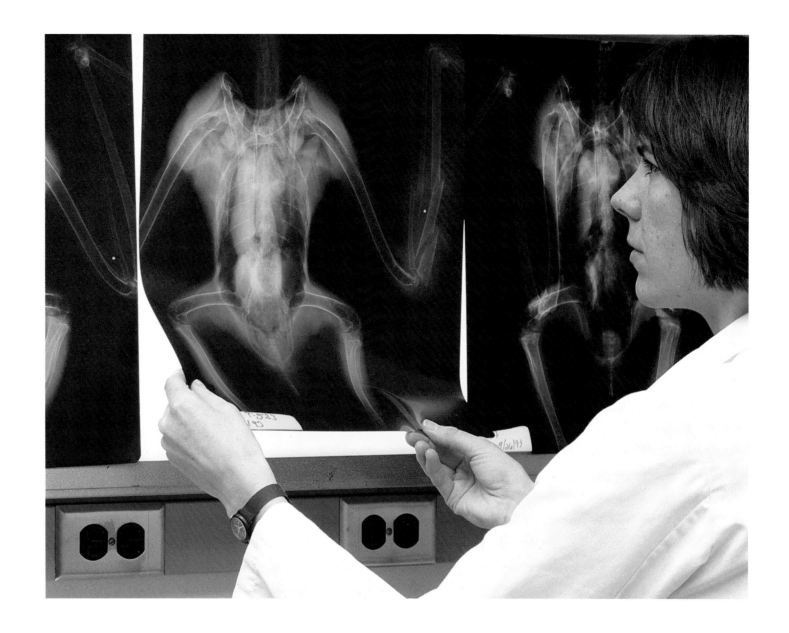

In the busy examination room, a doctor in a white jacket peers at an X ray displayed on a lighted screen. She looks closely at the delicate skeleton outlined on the film. Two of the bones are badly broken. This patient needs an operation right away to repair the damage. The doctor goes to scrub up, while her assistants hurry to prepare the patient and the operating room for surgery.

The patient headed for surgery is not a person. It's a bird—a bald eagle—with an injured wing. The doctor is a veterinarian, and she will perform the operation not in a hospital but at an animal rehabilitation center.

All the patients at the Gabbert Raptor Center in St. Paul, Minnesota, are raptors, or birds of prey, that have been hurt in some way. This nonprofit organization, located on the campus of the University of Minnesota, is dedicated to rehabilitating injured raptors—healing them and returning them to normal lives in the wild.

Each year, as many as six hundred raptors are treated at the Raptor Center, known as TRC to its friends. The birds are brought in by conservation officials or by people who have found them in fields and woods. Sometimes people drive hundreds of miles to deliver a patient to the center. Other raptors arrive by plane, shipped as airfreight in animal carriers. Many of the center's patients come from the midwestern states, but injured birds have been received from almost all parts of the United States, as well as from some foreign countries.

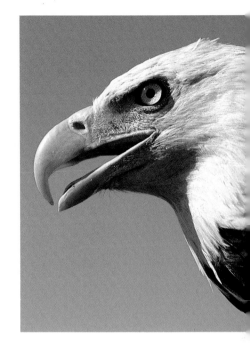

Raptors have strong legs and feet, sharp talons, and large, hooked beaks. All these features are useful in catching and killing prey.

Just who are the Raptor Center's patients? Raptors are birds that live by killing and eating other animals. Although many birds are meat eaters, raptors are specialists in hunting and killing prey. Their name comes from the Latin word *rapere*, which means "to seize" or "to snatch." Zooming down from the sky, these predators grab rodents, rabbits, fish, and other birds with the sharp talons, or claws, on their feet. Most raptors kill with their powerful feet and tear up prey with their large, hooked beaks.

In addition to their hunting skills, raptors have excellent eyesight and hearing, many times better than the senses of humans. Most are also skillful fliers, able to soar for hours or dive at high speeds after prey.

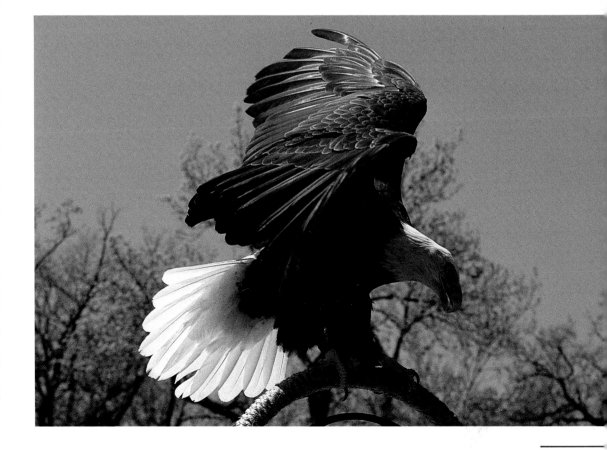

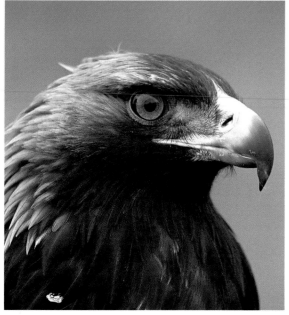

Golden eagle

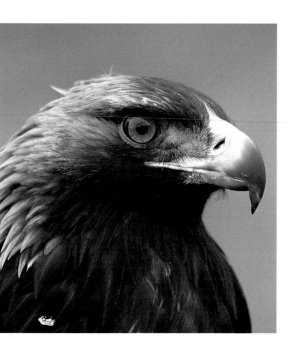

Barred owl

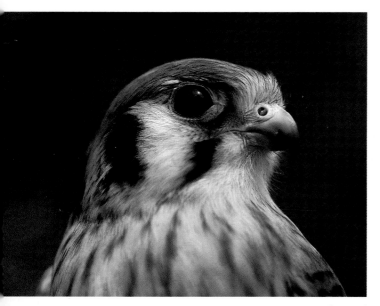

American kestrel

The golden eagle (Aquila chrysaetos) and the bald eagle (Haliaeetus leucocephalus) are the only two eagle species native to North America. Both have wingspans of more than six feet.

The American kestrel (Falco sparverius) sometimes lives in cities, where it makes its nest on the ledges of tall buildings.

The barred owl (Strix varia) makes its home in forests and swamps. Its name comes from the dark bars or stripes on its feathers.

The peregrine falcon (Falco peregrinus) is the fastest of all birds. When it dives down to capture prey, it can reach speeds of over two hundred miles per hour.

The red-tailed hawk (Buteo jamaicensis) is a very common raptor found in almost all parts of North America. It is often seen perching on utility poles and fence posts.

The great horned owl (Bubo virginianus) is such a large and fierce predator that it is sometimes called a tiger with wings. The tufts on its head are not horns or ears, but are used for display and camouflage.

The snowy owl (Nyctea scandiaca), unlike most other owls, often hunts during the day. A bird of the Arctic, it moves south in search of prey when food is scarce.

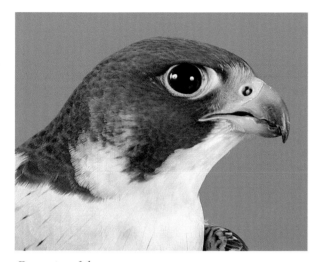

Peregrine falcon

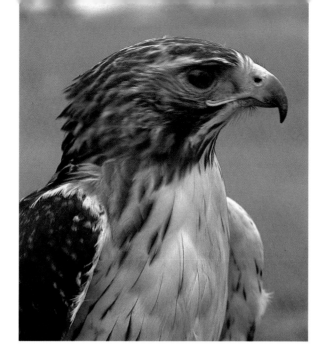

Red-tailed hawk

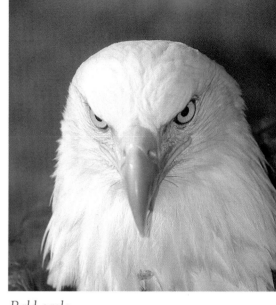

Bald eagle

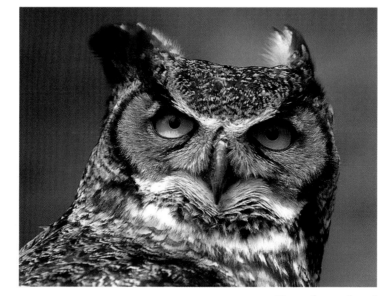

Great horned owl

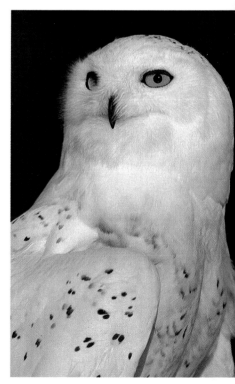

Snowy owl

Eagles are raptors, as are hawks, falcons, ospreys, and vultures. Owls are also considered members of the group. There are about 225 kinds of raptors living in almost all parts of the world. They range in size from the Andean condor—a giant vulture with a wingspan of twelve feet—to the tiny elf owl, which is smaller than a robin.

There are about fifty-five species of raptors in North America. They live in many different environments, including forests, mountains, plains, deserts, and arctic tundra. Some are even found in large cities. Pictured here are a few of the raptors that make their homes in North America.

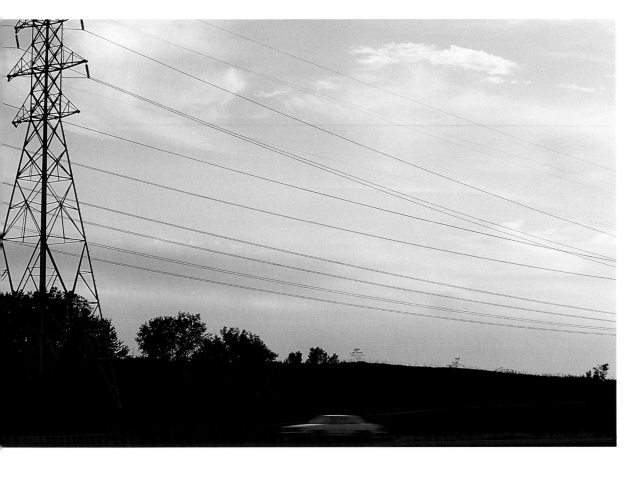

Because raptors are at the top of the food chain, few other animals threaten them in the wild. But humans and their activities pose a serious and growing danger to these remarkable birds.

In recent times, some raptor species have become almost extinct because of the use of pesticides. Other raptors are threatened by the loss of their habitats. When raptors disappear, the animals they prey on increase in number. The balance of entire ecosystems can be upset by the loss of these birds.

Human activities threaten individual raptors as well as whole species. Even in the remote areas where most of the birds live, there are many hazards. Power lines on tall poles cut through forests, and cars speed along highways. People armed with shotguns hunt game, while others set traps to catch furbearing animals. All these things can cause injury to raptors. The birds crash into power lines and poles or are hit by cars. They are shot by hunters or caught in traps meant for other animals. Even if the birds do not die from their injuries, they may be left crippled and unable to hunt.

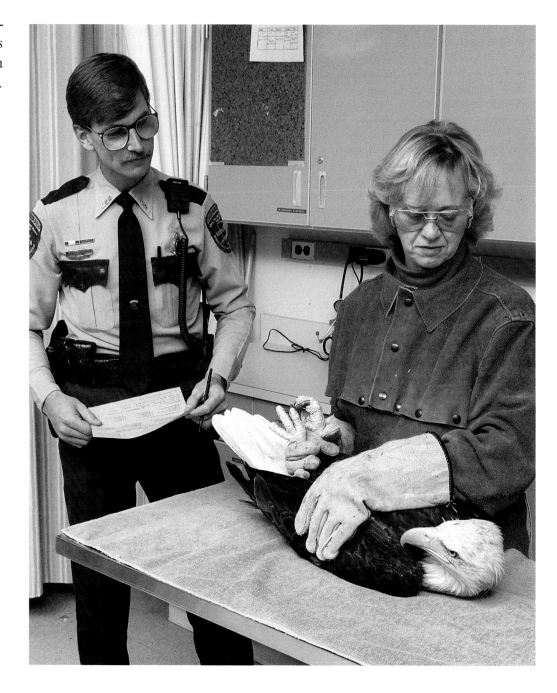

The bald eagle whose X ray we saw earlier has a gunshot injury. This eagle was brought to the Raptor Center by a conservation officer who works for the state of Minnesota. He found the injured bird in a ditch along a county road near the Mississippi River, where bald eagles often make nests. The officer approached the eagle cautiously from the rear to avoid its sharp beak and flapping wings. He wrapped it in a blanket and put it in an animal carrier. Then he drove as fast as he could to the Raptor Center.

During weekday hours, the center is always open and ready to receive patients. At night and on weekends, injured raptors are taken to the emergency room at the University of Minnesota's large veterinary hospital. On call twenty-four hours a day, TRC vets are notified by beeper that a patient needs their help.

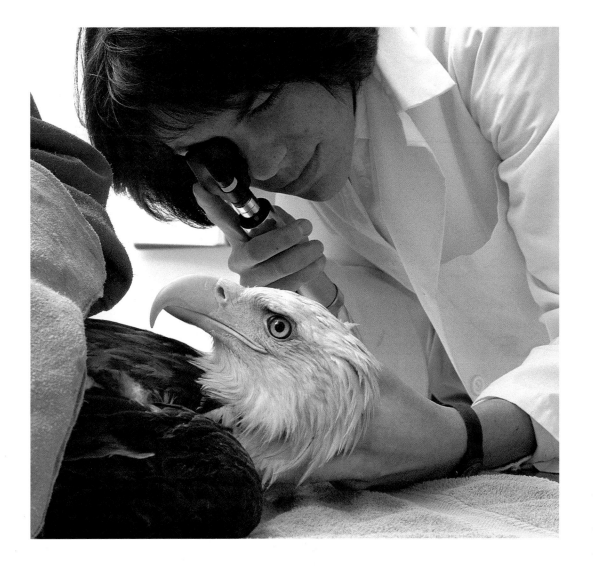

When an injured raptor arrives, TRC staff members first fill out an admissions form, recording when and where the bird was found and other useful information. The patient is then given a number, but usually not a name. Only birds that stay at the center for a long time are named.

After the paperwork is done, the raptor gets a physical examination. A veterinarian checks it carefully, weighing it, taking blood samples, and making X rays. One of TRC's volunteers helps the vet during the exam. There are two hundred of these unpaid workers who do all kinds of jobs at the Raptor Center, from cleaning cages to assisting in surgery. They put in more than twenty-one thousand hours each year.

Now known as Patient S-137, the bald eagle brought in by the conservation officer is not in good condition. Its body is very weak and thin. The bird probably hasn't eaten for some time because its wing injury has prevented it from flying after prey. Eagle S-137 will be given some food in liquid form before it receives any other treatment.

When the veterinarian examined the X rays, she discovered that this raptor had been hit by shotgun pellets, which were still lodged in the left wing. Many of the eagles that come to the Raptor Center have injuries caused by guns. Often they have been shot accidentally by people hunting game birds. But sometimes eagles are deliberately shot, for reasons that are hard to understand. One golden eagle brought to TRC had been shot and then beaten by two teenagers who were hunting rabbits. They said they attacked the bird because it killed too many rabbits and didn't leave enough for them! Despite its severe injuries, that golden eagle was rehabilitated successfully.

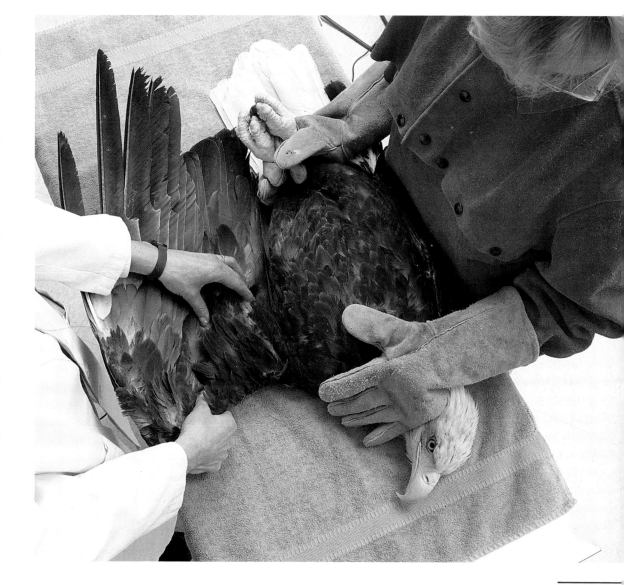

The injuries suffered by Eagle S-137 are not as serious as the injuries of the golden eagle. An operation will be needed, however, to repair the broken bones in its wing.

Just like any patient before surgery, the bald eagle receives an anesthetic to prevent it from feeling pain. Its head is covered with a plastic cone connected to a tank of gas. As the gas hisses into the cone, the bird's eyes close and it loses consciousness.

Wearing scrub gowns and masks, the veterinarian and her assistant work on

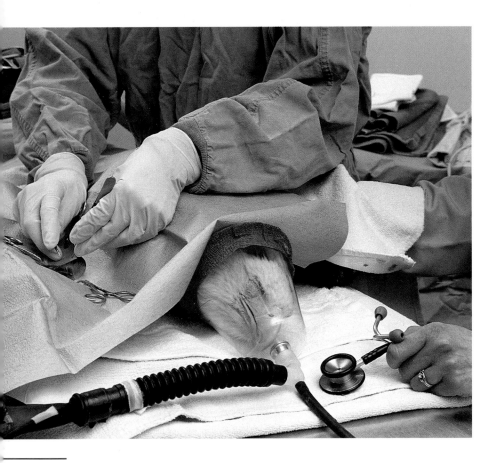

the injured wing. They clean out the wound and repair the breaks with metal rods. During the operation, they use scalpels, retractors, and other instruments very much like those used in operations on human patients.

Many of the Raptor Center's patients end up on the operating table. They need surgery not only to repair broken wings and legs but also to remove objects from their bodies. Fish-eating raptors, such as the bald eagle, sometimes swallow fishhooks or lead sinkers. Other raptors feed on birds killed by hunters, and they get lead shotgun pellets in their digestive systems. If these pellets are not removed, they can cause lead poisoning, a disease that damages the nervous system and that can be fatal if not treated.

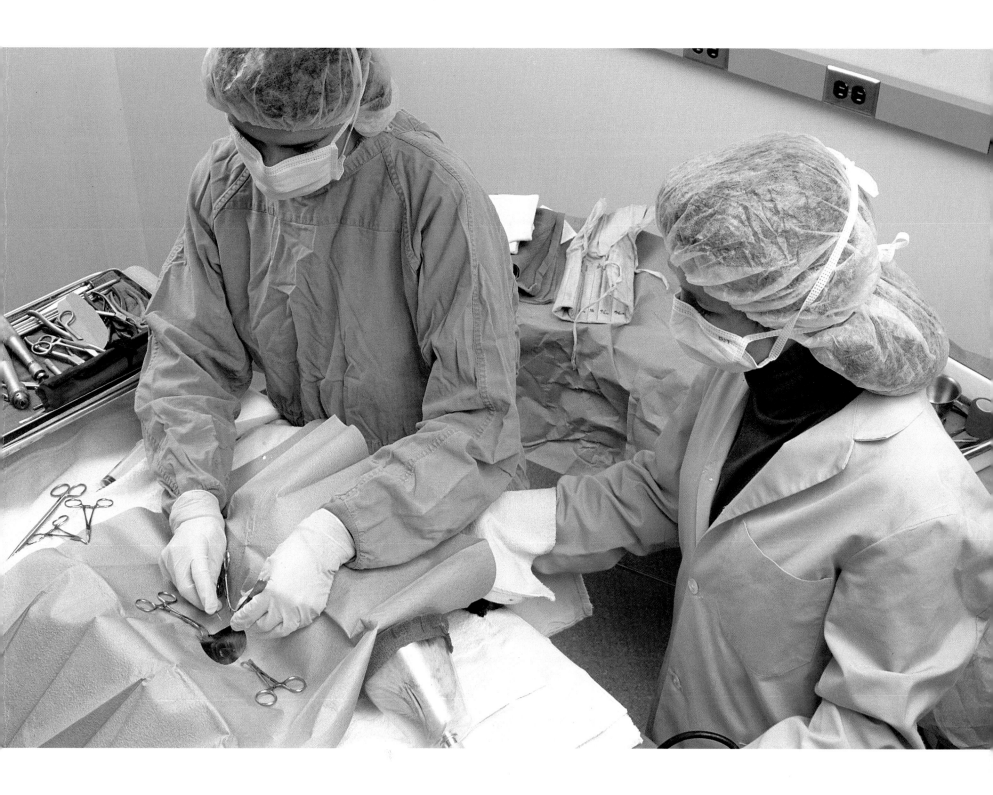

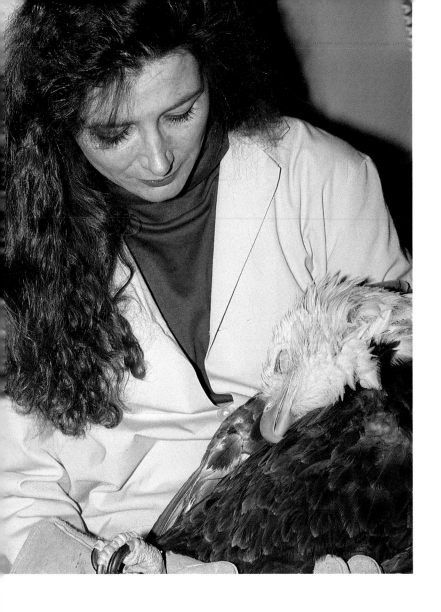

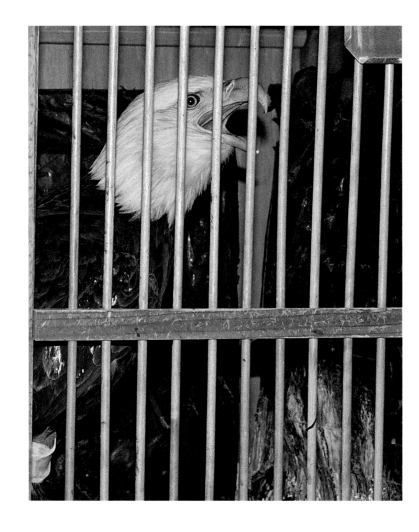

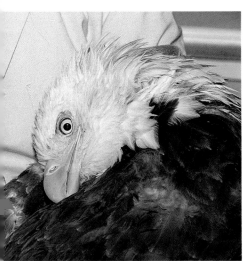

Birds with very serious injuries may be on the operating table for up to three hours, but Eagle S-137 is finished in about one hour. After the operation, a volunteer holds the eagle in her arms until it regains consciousness. This prevents the bird from hurting itself when it wakes up suddenly and begins thrashing around.

With head drooping and eyes closed, Eagle S-137 is still fast asleep. But in about twenty minutes, the bird begins to stir, and its fierce yellow eyes open.

When the eagle is able to stand by itself, it is put in a small cage. The cage is placed in a quiet, dark room where the natural process of healing can begin.

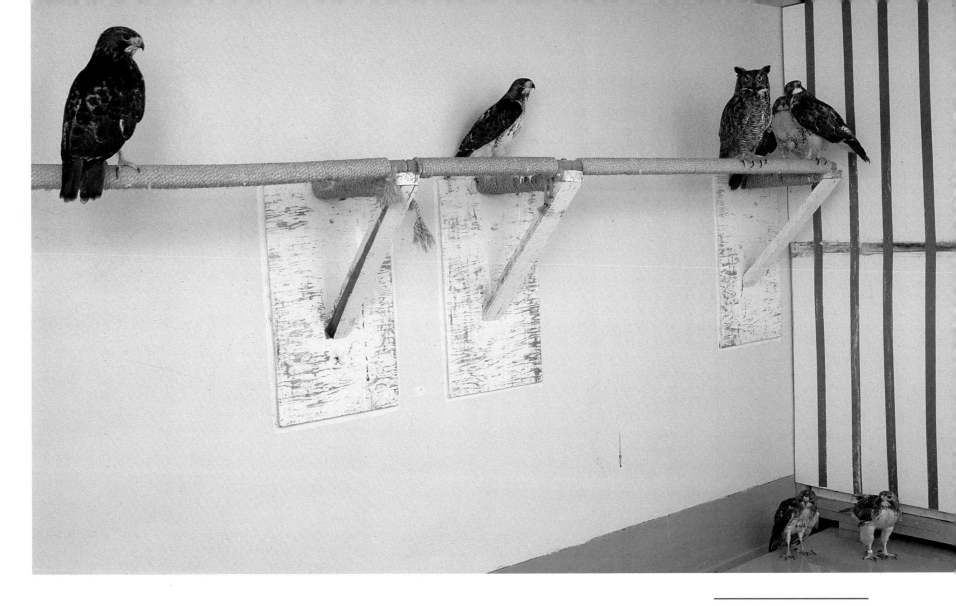

After its broken wing has mended, the eagle will be moved to a flight room, which it will share with other recovering eagles. This room has perches fastened to the walls at different levels. The birds can fly from the floor to a perch and back down again. The exercise strengthens their wings and flight muscles and helps them get back in flying condition.

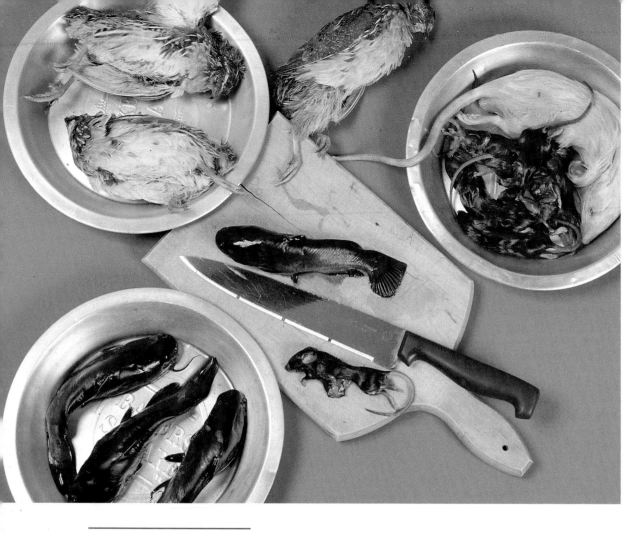

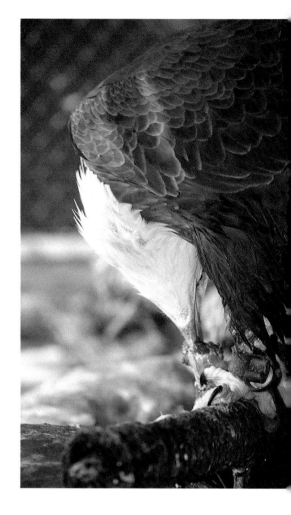

In the wild, bald eagles eat mostly fish. At the Raptor Center, their diet also includes birds and rodents.

While raptors are patients at TRC, they receive excellent care. They are given antibiotics to prevent infection. Their cages are cleaned regularly by volunteers. The raptors are fed a nourishing diet of dead fish, mice, rats, and birds.

The rehabilitation of an injured raptor usually takes about eight to ten weeks. But some birds have to stay at the Raptor Center for many months. The longest stay was two full years. Some raptors are so crippled when they arrive at the center that they can never be released back into the wild. They become permanent residents at TRC and are used as education birds in the center's programs.

Eagle S-137 has now been at TRC for five weeks and seems to be making a good recovery. Staff members are carefully watching its progress. They take X rays to see if the broken bones are healing. They also observe the bird during flight tests.

After six weeks of rest, the eagle is brought to an outdoor pen. Each of these large pens near TRC holds several raptors. The birds have room to move around and to fly short distances. Once Eagle S-137 reaches this stage in its rehabilitation, staff members set up an individualized exercise program for it. Now it will be able to do some real flying.

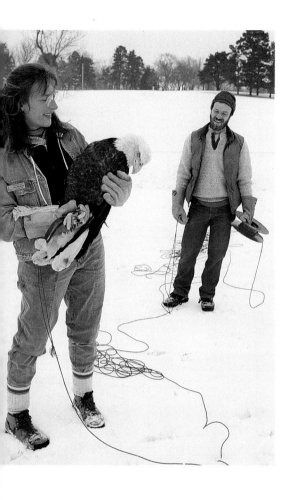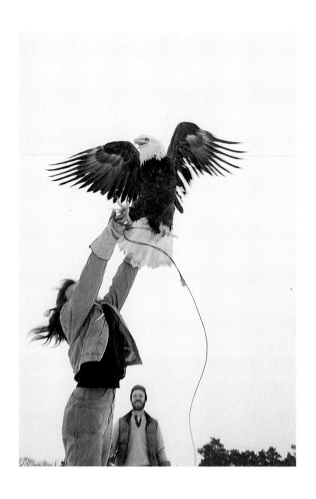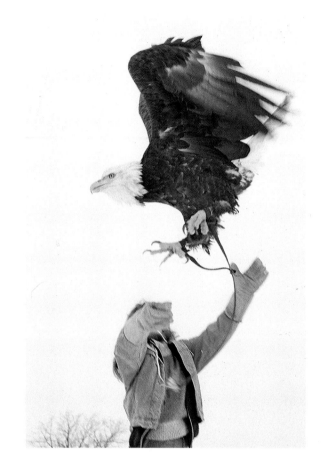

Every few days, volunteers on the flight crew put the eagle in a carrier and take it to a nearby park. There they attach a line or tether, one hundred yards long, to leather straps on the bird's legs. A member of the flight crew holds the end of the tether, while another tosses the eagle up into the air.

The bird flaps its wings bravely and tries to fly, but it doesn't go very far. Its flight muscles, the large muscles in a bird's breast that control the wings, are still weak.

When the eagle lands, the volunteer picks it up and sends it off again. During the first exercise session, the bird flies only twice before being taken back to its pen

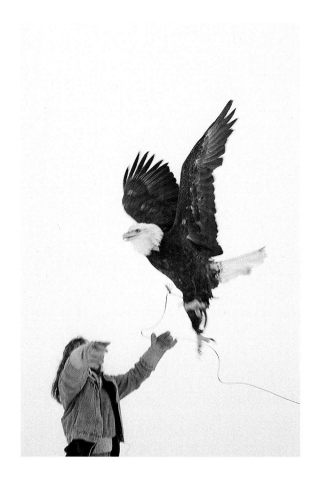 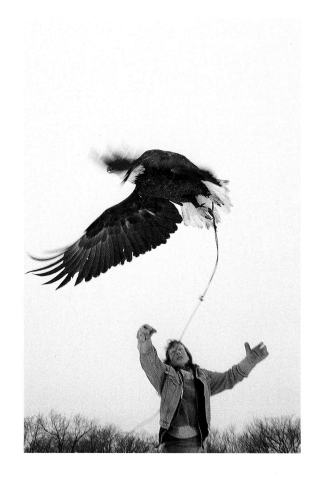 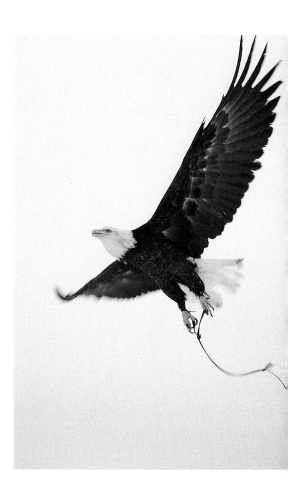

at the Raptor Center. As Eagle S-137 builds up its strength, it will make more flights during each session. Six or seven flights per session provide the best workout for a recovering bird.

During exercise flights, the tether usually keeps the birds from making a break for freedom. But there was one determined bald eagle who managed to get loose from its tether and escaped to a nearby golf course. It took fifteen hours for TRC staff to get the bird back, and they needed the help of the fire department. Because wet feathers make it harder for a bird to fly, firefighters sprayed the fugitive with water. After the eagle was hosed down several times, it was finally captured.

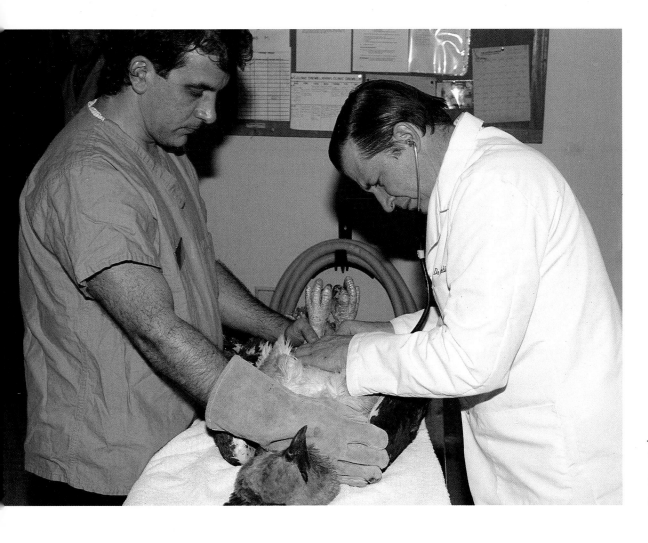

The Raptor Center's director, Dr. Pat Redig (right), *examines a harpy eagle with the help of biologist Mark Martell.*

The Raptor Center staff spends a lot of time caring for patients, but there are also other jobs to do.

Research is a big part of TRC's work. Staff members are studying all kinds of problems that affect raptors, such as lead poisoning. Since lead is also dangerous to people, research on this life-threatening condition may help humans as well as birds. Other researchers at TRC are doing field studies on threatened species of raptors, such as peregrine falcons. To help save the birds from extinction, scientists want to learn more about how they live in the wild—what foods they eat, where they build nests, and what kind of habitats they prefer.

TRC's staff had a chance to do some truly unusual research in 1994 when a rare harpy eagle came to the Raptor Center. Harpies live in the forests of Central and South America, where they hunt monkeys and sloths. The harpy that became a TRC patient was from Venezuela. It had been shot by poachers who were hoping to capture and sell the rare bird.

Environmental groups in Venezuela knew about TRC's reputation for successfully treating raptors with serious injuries. Through their efforts, the eagle was brought to Minnesota. It was the longest journey that a TRC patient had ever made.

The harpy eagle's broken leg was repaired during a three-hour operation. Several weeks later, however, the bird died from liver failure. Everyone felt sad about the loss of the beautiful eagle. But what researchers learned in caring for this one bird may help to save hundreds of endangered harpy eagles.

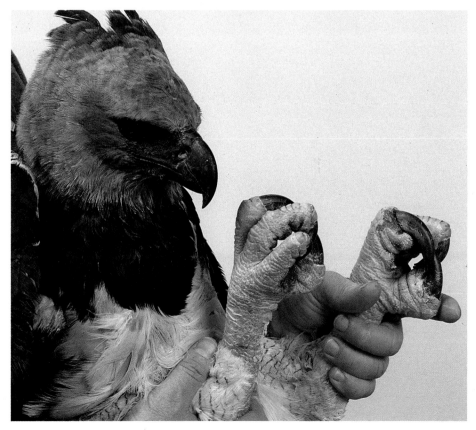

The harpy eagle's feet are as big as a man's hand.

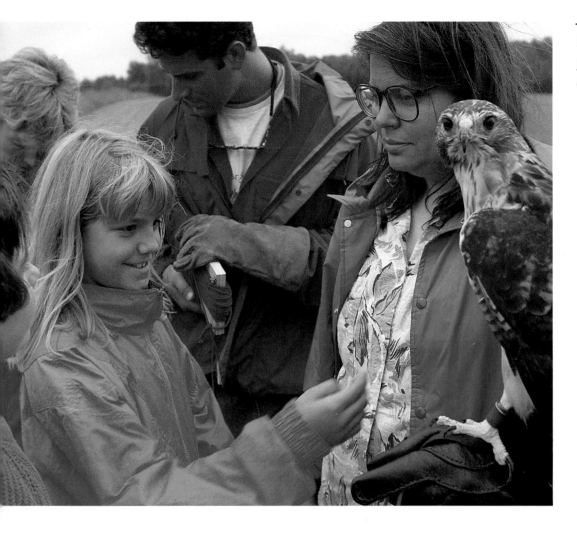

Another big job of TRC's staff is education—helping people learn about raptors. The Raptor Center always welcomes visitors. Every day, families and school groups come to see the displays and to meet Othello, Leuc, Yankee, and the other education birds. Othello and his friends also visit many schools, accompanied by TRC volunteers.

One popular program at TRC gives people the opportunity to adopt one of the center's patients. Through donations, individuals or groups help pay for the care of an injured bird. Adoption is a popular project for schools. The students choose their favorite kind of raptor—eagle, hawk, falcon, or owl—and receive reports on their bird's progress.

For a more personal experience with raptors, some young people go to Raptor Camp. This two-week summer program includes classes, field trips, and special projects, such as building houses for screech owls to nest in. At Raptor Camp, kids learn to understand these beautiful wild birds by meeting them "nose to beak."

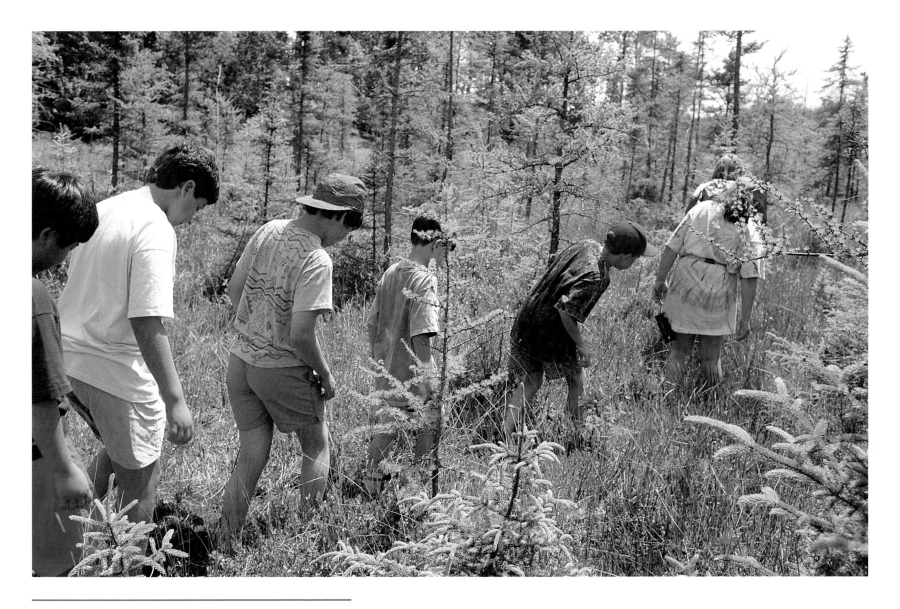

Raptor campers take a "bog walk" with a naturalist.

Of all the activities at the Raptor Center, the public bird releases are the most popular. Most of the raptors rehabilitated at TRC are set free whenever they are ready to fly. But twice a year, people are invited to watch the release of several birds and to join in celebrating their freedom.

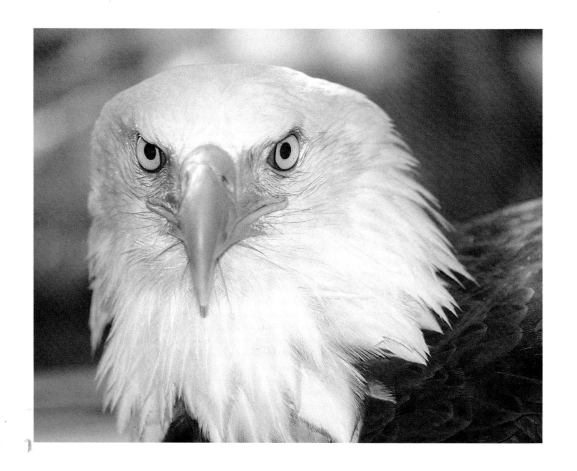

The bald eagle whose progress we have been following will be among the raptors released this spring. Its broken bones have completely healed. Eagle S-137's flight is well balanced; it is using both wings equally. Only one more thing needs to be done before the eagle can return to the wild. A broken tail feather must be replaced.

Feathers are replaced by a process called imping. First the broken feather is cut off. Then a new feather is attached to the old feather shaft with a bamboo stick and a little epoxy glue.

The Raptor Center has a cabinet filled with envelopes containing feathers, all marked by species and type. The bald eagle needs a Number Four tail feather. Once the new feather is in place and the glue has dried, Eagle S-137 will be ready to fly.

In preparation for imping, the broken feather is cut off.

Glue is applied to a bamboo stick that has been inserted into the shaft of the new feather.

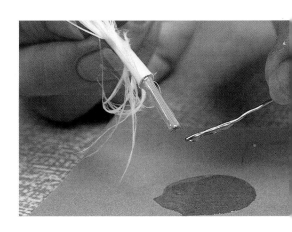

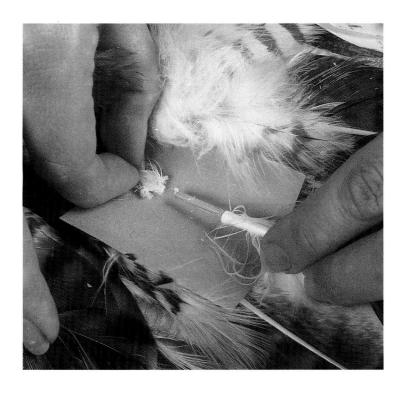

The new feather is joined to the old one. After the glue dries, the bird is ready to fly.

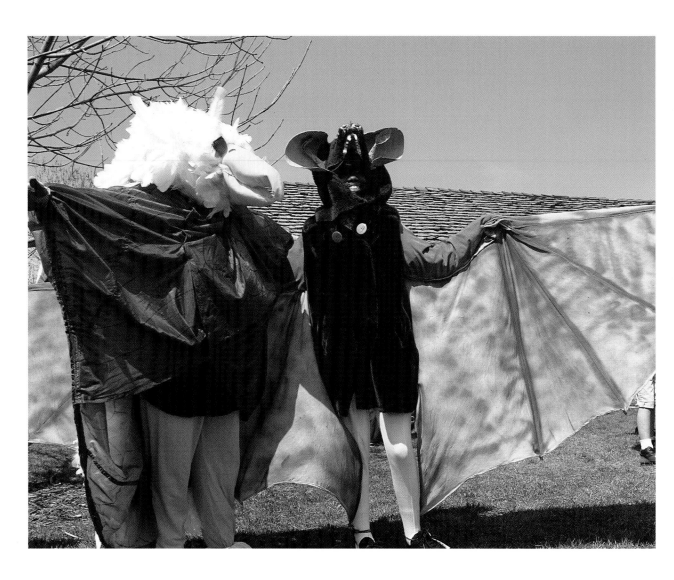

The day of the release is cool and windy, with the sun peeking out from behind some clouds. By one o'clock, the state park where the event will take place is crowded with people.

There are many things for the visitors to do. They can buy T-shirts decorated with pictures of eagles and owls. They can talk to TRC volunteers dressed in animal costumes or take photos of Othello and the other education birds.

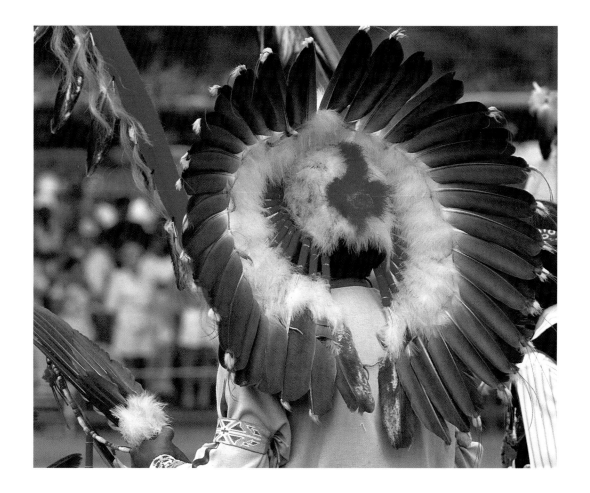

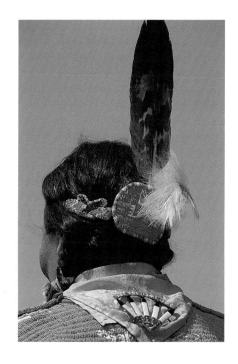

As part of the celebration, a group of Native Americans from the local community dances to the beat of a drum. Some of the dancers carry eagle-feather fans or wear feathers in their hair. For many Native Americans, the eagle holds great importance. It is connected with powerful forces in nature like wind, thunder, and the sun. Eagles are sometimes considered messengers between humans and the spiritual world. Their feathers are sacred symbols of power and honor, used in dances and religious ceremonies.

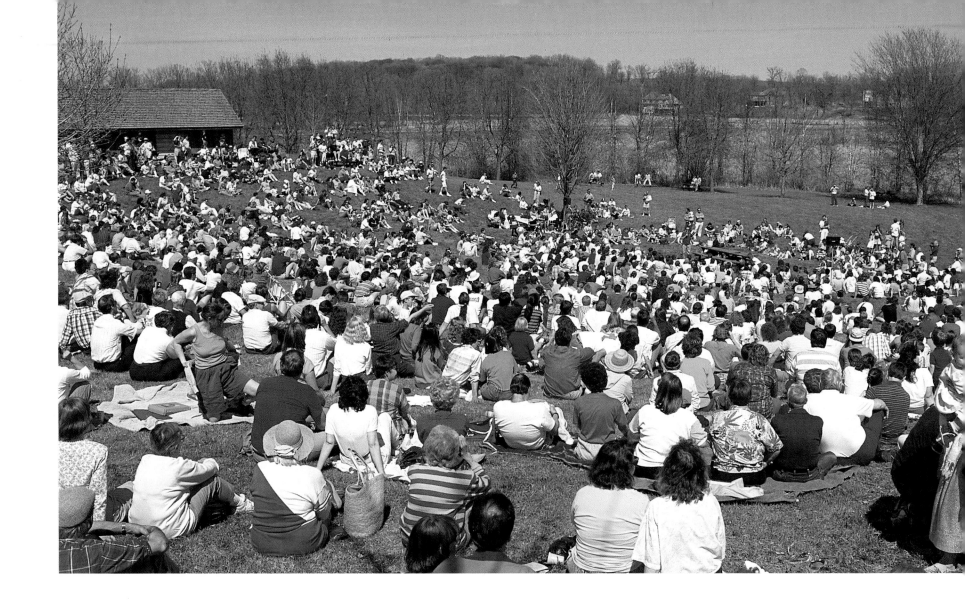

By two-thirty, the dancing is finished, and the T-shirt stands have closed. At last, it's time for the bird release.

Eight raptors, including Eagle S-137, have been waiting patiently inside their carriers. Each bird will be released by a person who has been specially chosen for this honor. Some are local officials or important visitors. Others are people who have given money to support the Raptor Center's work. One lucky person won a drawing held earlier today.

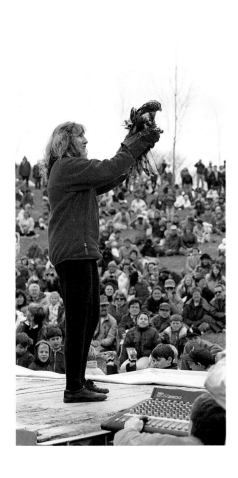
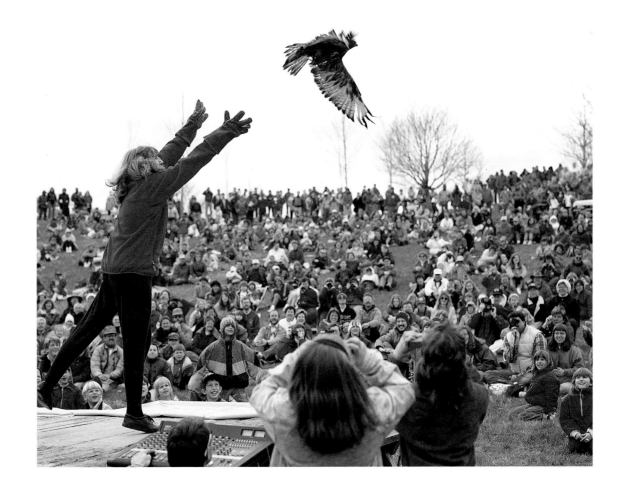

After an introduction by a staff member, the first releaser comes forward. She is wearing a pair of heavy leather gloves to protect her from the bird's sharp talons. A volunteer gives the woman instructions and then puts one of the birds into her hands. It is a young red-tailed hawk.

The releaser holds the hawk up high and turns around slowly so that everyone can see it. Then, with a quick movement, she throws the bird into the air. The hawk flies low over the crowd and quickly disappears into the trees.

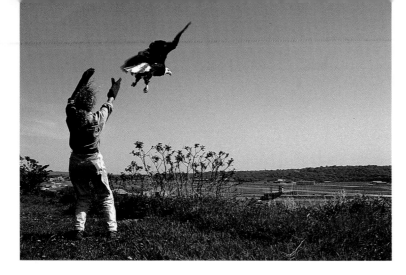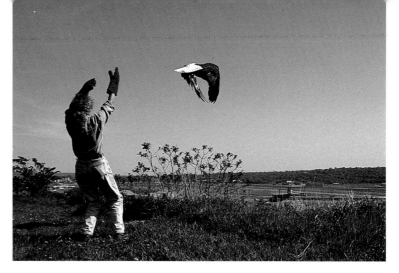
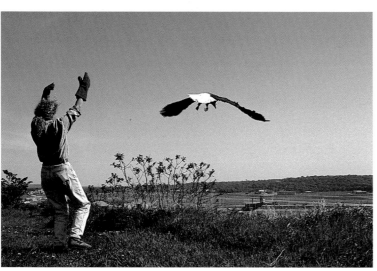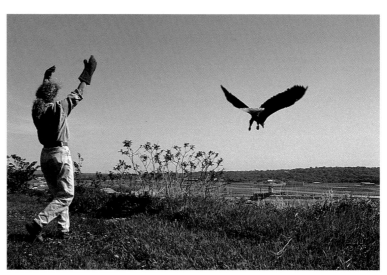

Next, a great horned owl is released, and then another hawk. Now it is the bald eagle's turn to fly. The bird is brought forward, the sunlight shining on its white head. The releaser carefully takes the eagle in her hands. She shows the bird to the crowd and then lets it go.

The bald eagle does not waste a second of its freedom. It beats its wide wings and flies straight toward the sun. People clap and cheer, and some even wipe away a few tears.

Everyone watches until the eagle is out of sight. Then they turn back to see another raptor fly to freedom, healed and whole again, thanks to the efforts of the dedicated people at the Raptor Center.

What You Can Do to Help Raptors

People who care about raptors recently heard some very good news. In June 1994, the U.S. Fish and Wildlife Service announced that the bald eagle would soon be taken off the list of endangered species. Thirty years ago, there were only about four hundred pairs of bald eagles left in the lower forty-eight states. Today that number has climbed to more than four thousand, thanks to conservation efforts.

The return of the peregrine falcon is another raptor success story. Almost extinct in the 1960s, peregrines were saved by captive-breeding programs and by a 1972 law that banned the use of the pesticide DDT. (This chemical damages eggs laid by falcons, eagles, and other birds.)

Despite this good news, raptors are still threatened by many dangers. What can *you* do to help these beautiful wild birds? If you find an injured raptor, notify a conservation official in your area. (Look in the government section of the telephone book for a number.) You can also help by supporting the work of organizations such as the Raptor Center that care for injured raptors. Maybe your family or your school would like to adopt a TRC patient.

Of all the threats to raptors today, one of the most serious is the loss of their habitats. The wild places where eagles and other raptors live are gradually being taken over by people. Trees are being cut down and swamps filled in so that more shopping centers and recreation areas can be built. Protecting wild habitats is one of the best ways to help raptors. You can lend a hand by writing letters to public officials who make decisions about the environment or by joining organizations that support the cause of habitat protection.

For more information about raptors and what you can do to help them, contact the Raptor Center:

Gabbert Raptor Center at the University of Minnesota
1920 Fitch Avenue
St. Paul, MN 55108
Phone: (612) 624–4745
FAX: (612) 624–8740

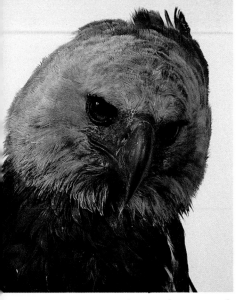

A rare harpy eagle

More about Raptors

• Raptors have gone through millions of years of evolutionary change to reach their present forms. The oldest fossil remains of raptors have been found in North America and include *Teratornis incredibilis*, a vulture-like bird with a wingspan of seventeen feet.

• Many scientists classify modern North American raptors into five families. The large hawk family includes hawks, eagles, kites, and ospreys. Falcons have their own family, as do vultures. Owls belong to two different families. Other experts put ospreys in a separate family.

• Owls have many features that set them apart from other raptors. Most are nighttime hunters, while hawks, eagles, and falcons are active during the day. Owls usually use their keen hearing to find prey, while other raptors depend more on their eyesight.

• Most hawks belong to one of two different groups. *Buteos* have long, wide wings and hunt by soaring over open country. The red-tailed hawk is a typical North American buteo. *Accipiters* are short-winged hawks that usually hunt in forests and prey on birds. The northern goshawk is a member of this group.

• The bald eagle, the national symbol of the United States, is not really bald. Its name comes from an Old English word for "white" and refers to the adult bird's white head. The white head feathers develop when an eagle is about four or five years old.

• In most species of raptors, male and female birds have the same markings and colors. Females are usually larger than their male partners. Male and female raptors share the work of feeding and caring for their young.

• Eagle feathers used in Native American ceremonies are obtained from the federal government. Since it is illegal to kill raptors or to take their feathers, a government agency collects feathers of eagles killed accidentally and makes them available for this special use.

• Falconry is an ancient sport that uses raptors in hunting. As long ago as 2000 B.C., the Chinese were training falcons, hawks, and eagles to pursue and capture birds and other animals. Popular in Europe during the Middle Ages, falconry is still practiced today in many countries.